Washington's San Juan Islands
Charles Gurche
779.3679774

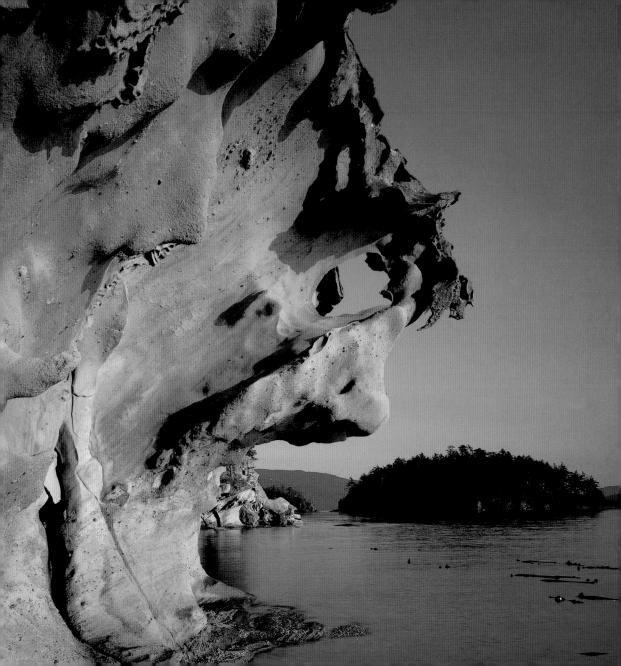

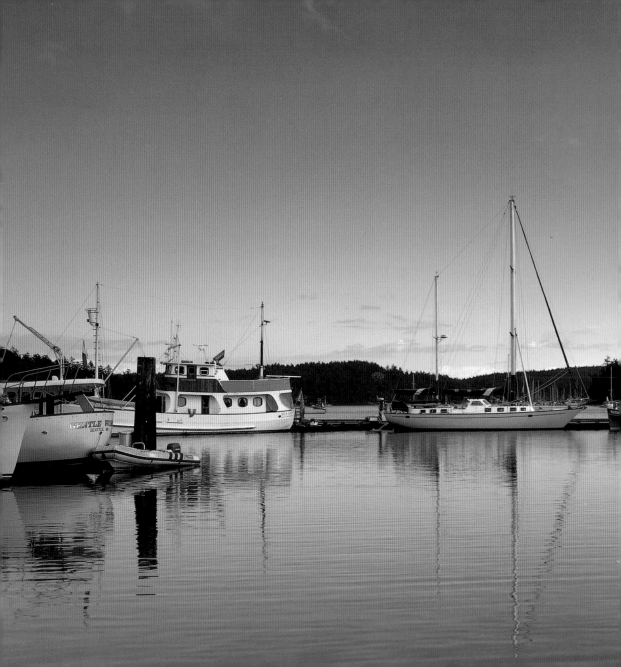

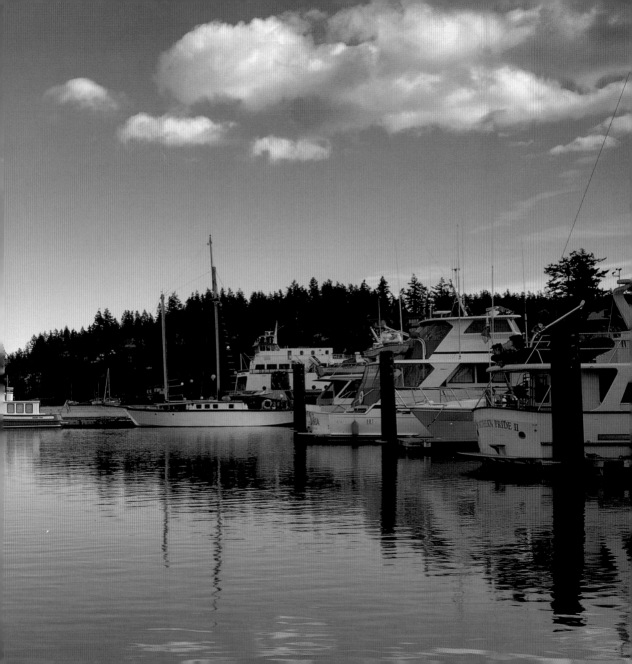

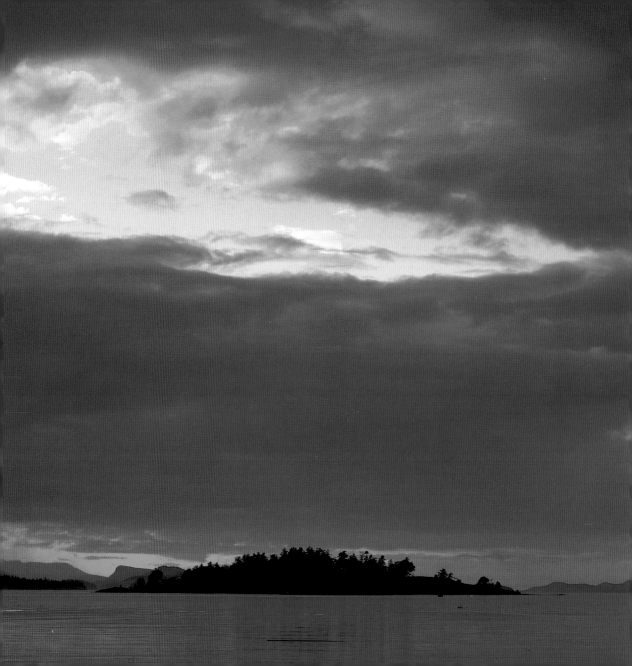

WASHINGTON'S SAN JUAN ISLANDS

Photography by Charles Gurche
With Selected Prose & Poetry

Washington Littlebooks

Westcliffe Publishers, Inc., Englewood, Colorado

First frontispiece: Sandstone formation, Sucia Island
Second frontispiece: Boats under blue skies, Friday Harbor, San Juan Island
Third frontispiece: Sunset, Yellow Island
Opposite: Agoseris along South Beach, San Juan Island

International Standard Book Number: 1-56579-139-8
Library of Congress Catalog Number: 95-62429
Copyright Charles Gurche, 1996. All rights reserved.
Published by Westcliffe Publishers, Inc.
2650 South Zuni Street, Englewood, Colorado 80110
Publisher, John Fielder; Editor, Suzanne Venino; Designer, Amy Duenkel
Printed in Hong Kong by Palace Press

I am very grateful to Steve Box for his splendid geologic maps and information about
coastline geology of the San Juan Islands; to Randy Gaylord, a great friend, guide, and
captain, for taking me to the outer islands; to Nancy Schaub for my incredible office space;
and to my wife Sara for her support, wisdom, and love.

— C. G.

Original prints available, contact Charles Gurche
at 509-534-2783

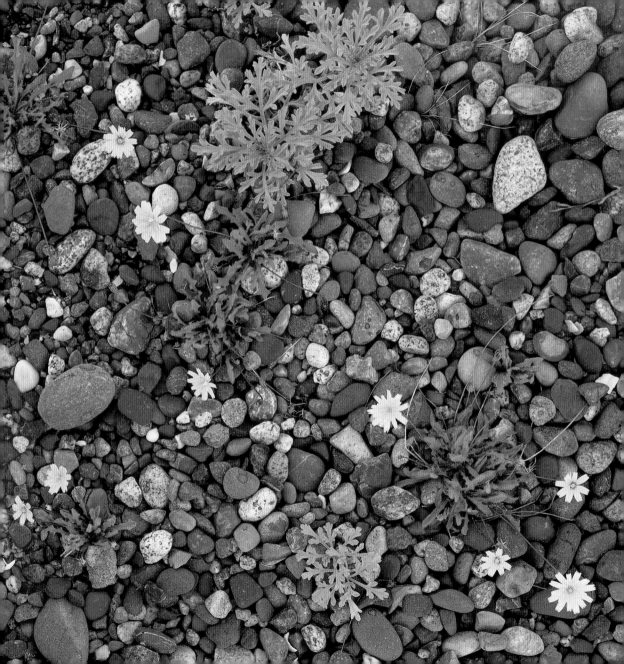

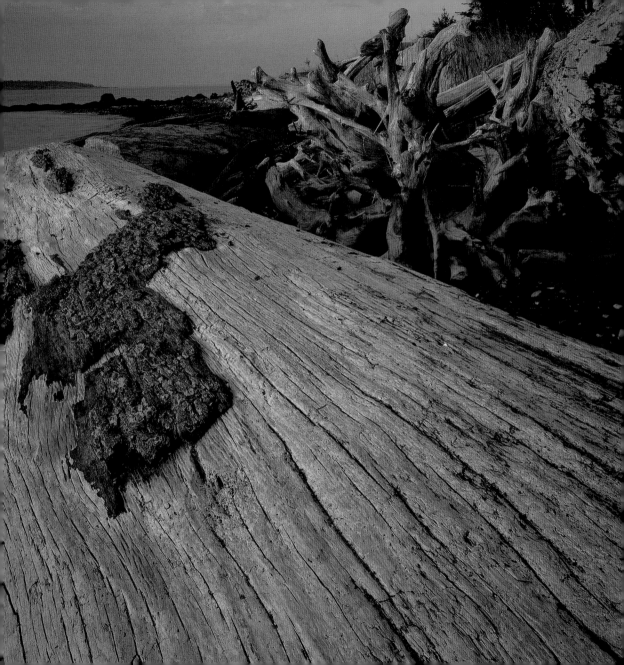

PREFACE

For most people, their first visit to the San Juan Islands is on one of the Washington State ferries, and it is often an awakening. First there is the sheer bulk and size of the ferry, and then, once underway, you anticipate the unknown and become aware of the vast expanse of water and sky. As the ferry continues, you relax and become calm as you absorb the simple beauty of motion, water, and sky.

I remember well my first trip. It was on a clear September day. The speed of the ferry created a cool, breeze that mixed with the warmth of the sun. Narrow channels offered glimpses of deep green forests mirrored in still water, of deserted beaches and rocky headlands. Islands and fragments of islands drifted in and out of sight. Everything seemed bright and sharp.

Because regular ferries service only four of the larger San Juan Islands, explorers of the 168 other named islands must find their way in sailboats, cruisers, kayaks, or canoes. On a cold autumn afternoon, I joined a friend for a photo exploration of Stuart Island. We left Deer Harbor on Orcas Island under a blanket of gray skies. By the time we reached Stuart, a soft drizzle lent a mysterious mood to the island's rocks and bays. Stuart is the farthest west of the San Juans, and only a mile from the Canadian border, with Sidney on Vancouver Island being the nearest town. Stuart's secluded harbors, abundant shellfish, and three state parks draw many summer explorers. In the dim light, I decided to postpone photography and instead noted some of the interesting places for a return trip.

As daylight waned on the way home, my friend suddenly shouted and pointed ahead. A moment later, an orca whale surfaced for a moment, then dove. We stopped the motor and drifted. Fifty yards in front of her, another, much smaller, whale popped up briefly. Young orcas remain with their mothers and will pod for their lifetime. After the infant dove, the mother came up one more time, then sounded with a steeply angled dive. We drifted a bit,

Driftwood, North Beach, Orcas Island

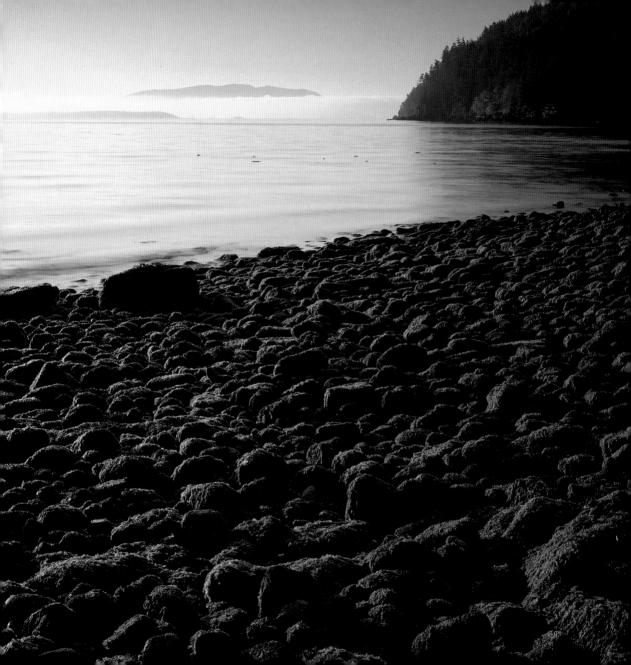

searching for the youngster and listening to the light rain, then continued, since orcas can stay submerged from three to four minutes, to depths of 500 feet.

The resident orcas number about 95 whales. The San Juan Islands are a haven for wildlife, with 84 locations designated collectively as the San Juan Islands National Wildlife Refuge. The islands and their waters host orca and minke whales, seals and sea lions, a variety of migrating and resident birds, and a rich assortment of tide pool life and shellfish. Each season offers a different look, with the annual cycle of feeding, breeding, and migrating.

Photography on the islands involves a combination of things: changing tides, shifting light, the cycles of weather and seasons. There was one night on Lopez Island with a sky so clear that I could see the Milky Way. In the cool morning I suspected that lakes and ponds on the island might be covered with morning mist. I arrived at Hummel Lake before dawn to find it blanketed with soft fog. Minutes later, the rising sun illuminated the fog with a glowing gold, and the entire scene was reflected in the mirrorlike water. My adrenaline flowed and I happily exposed film for about fifteen minutes, as the light and fog constantly changed.

These experiences, and many others, were the beginning of my acquaintance with the San Juan Islands. With these islands, it seems that the more you get to know them, the more there is to know. The photographs herein are also a beginning, only a small glimpse of the entire picture, and a starting point for the incredible realm of discovery the San Juans have to offer.

—Charles Gurche
Spokane, Washington

Seaweed-covered stones, Orcas Island

"Cloudy mornings may turn to clear evenings."

— John Ray, *English Proverbs*

Morning fog on Hummel Lake, Lopez Island

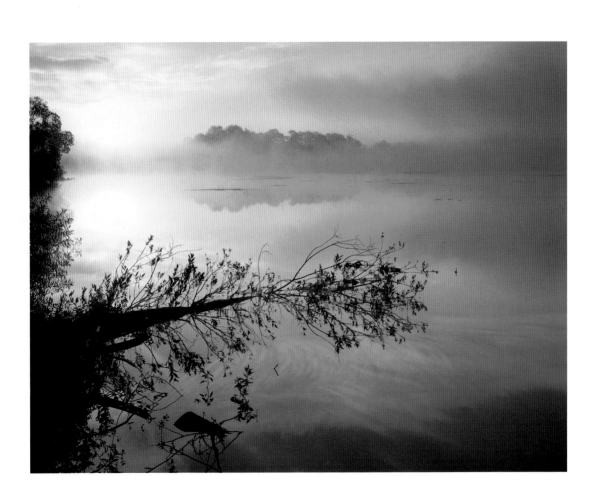

"Even the gods have dwelt in the woods...
The woods please us above all things."

— Vergil, *Eclogues*

Old-growth forest, Moran State Park, Orcas Island

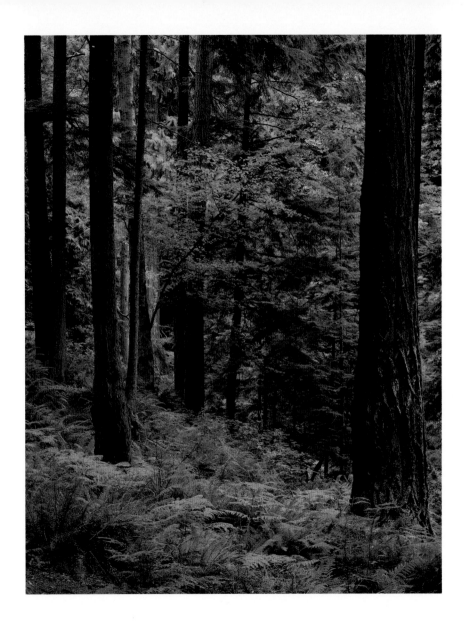

"A harbor, even if it is a little harbor, is a good thing,
since adventures come into it as well as go out,
and the life in it grows strong, because it takes something
from the world and has something to give in return."

— Sarah Orne Jewett, *Country Byways*

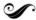

Sea kayaks, Roche Harbor, San Juan Island

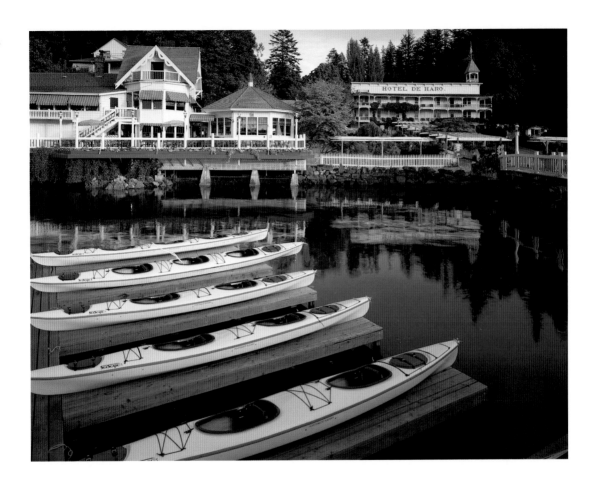

"All my life through, the new sights of Nature
made me rejoice like a child."

— Marie Curie, *Pierre Curie*

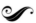

Starfish, Orcas Island

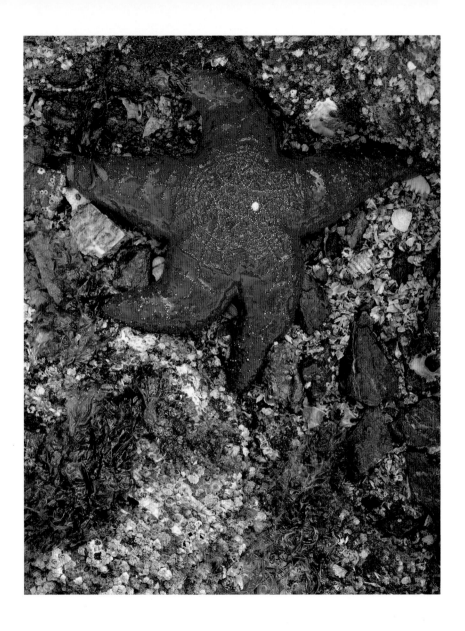

"Ever drifting, drifting, drifting
On the shifting
Currents of the restless main;
Till in sheltered coves, and reaches
Of sandy beaches,
All have found repose again."

— Henry Wadsworth Longfellow, *Seaweed*

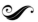

Fisherman Bay, Lopez Island

Overleaf: Lime Kiln Lighthouse, San Juan Island

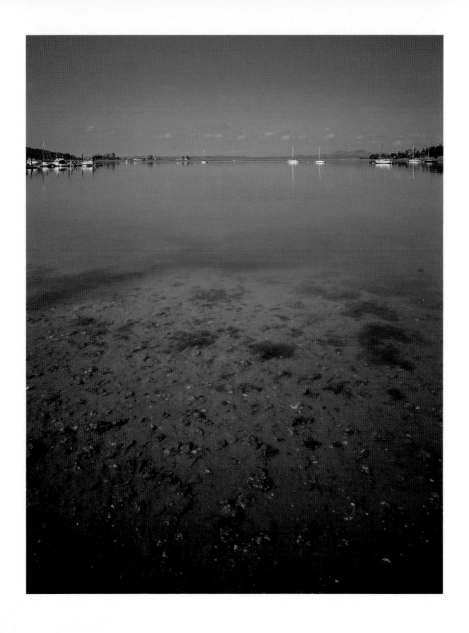

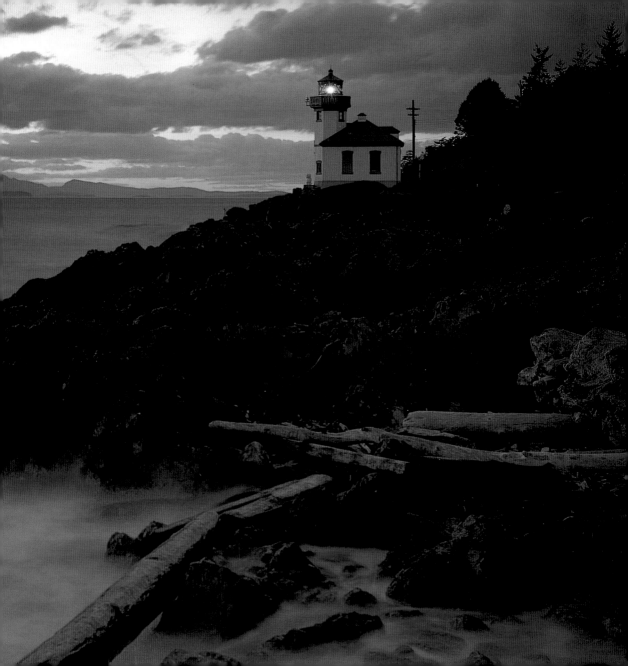

"As twilight began to fall, I sat down on the mossy instep of a spruce. Not a bush or tree was moving; every leaf seemed hushed in brooding repose."

— John Muir, *Travels in Alaska*

Fog-enshrouded forest, Moran State Park, Orcas Island

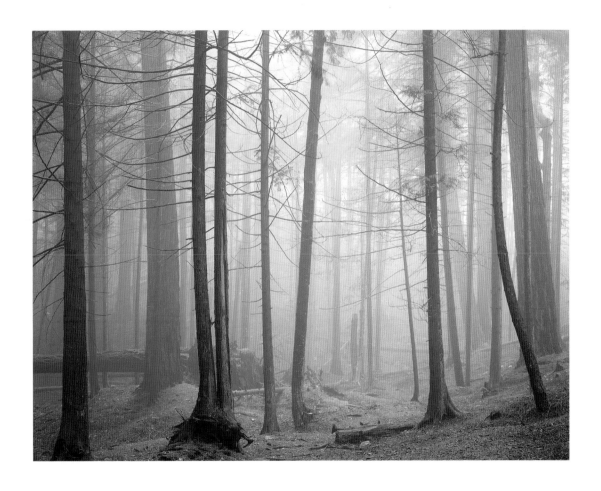

"Art should be Truth; and Truth unadorned,
unsentimentalized, is Beauty."

— Elizabeth Borton de Treviño, *I, Juan de Pareja*

Alder leaf, North Beach, Orcas Island

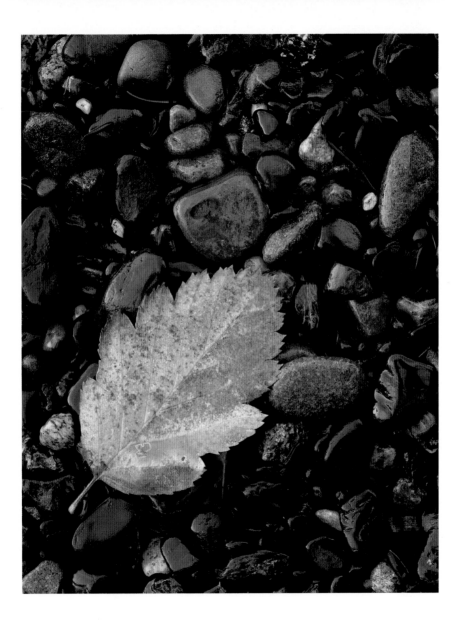

"...the moss-covered rocks are white-aproned with the clear mountain brooks that cascade down their sides from the dark, mantling pines and cedars above."

— John Burroughs, *Far and Near*

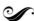

Cascade Falls, Moran State Park, Orcas Island

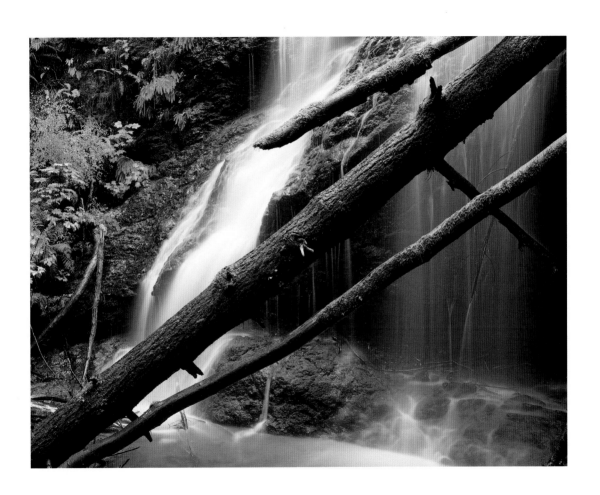

"The day was dying, the night being born — but with great peace. Here were the imponderable processes and forces of the cosmos, harmonious and soundless. Harmony, that was it! That was what came out of the silence — a gentle rhythm, the strain of a perfect chord, the music of the spheres, perhaps."

— Richard Byrd, *Alone*

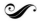

Neck Point at sunset, Shaw Island

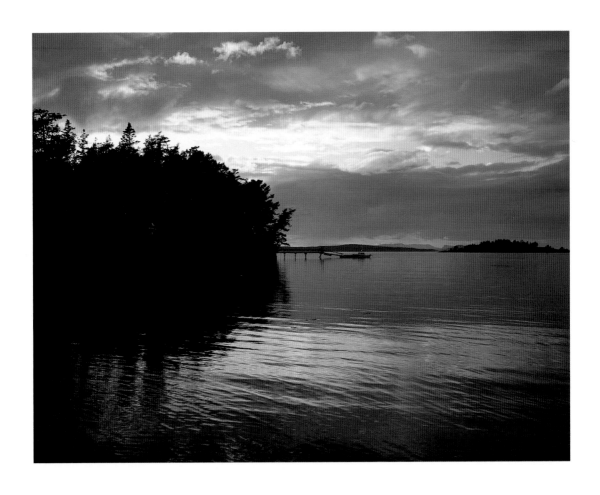

"Never be afraid to sit awhile and think."

— Lorraine Hansberry, *A Raisin in the Sun*

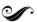

Center Church, Lopez Island

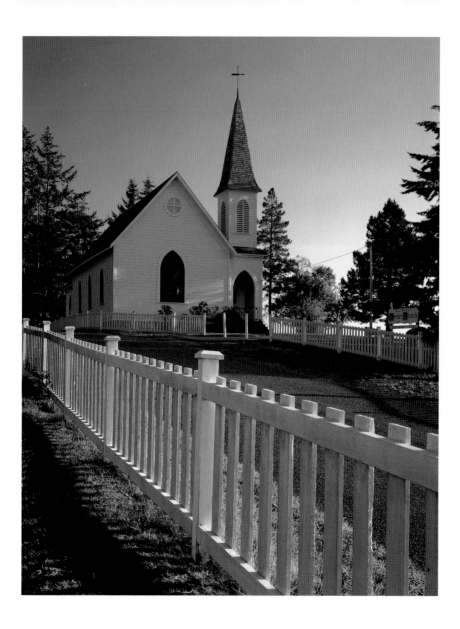

"The shores on each side of the straits are of a moderate height; and the delightful serenity of the weather permitted our seeing this inlet to great advantage. The shores on the south side are composed of low sandy cliffs, falling perpendicularly on the beaches of sand or stones."

— George Vancouver, *A Voyage of Discovery
to the North Pacific Ocean and Round the World, 1791-1795*

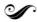

Evening light on Iceberg Point, Lopez Island

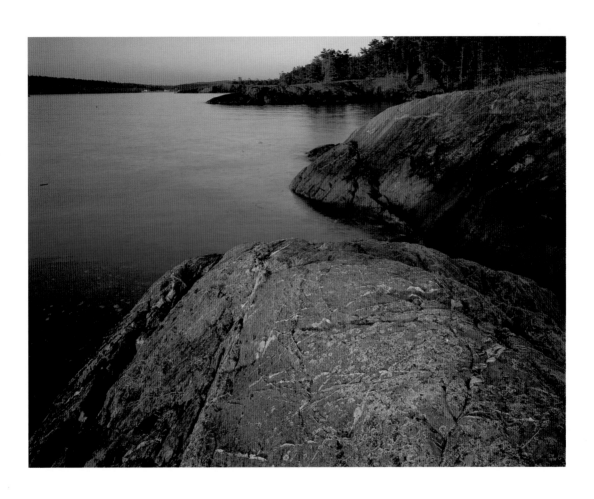

"…the Creator in making pea vine and locust tree had the same idea in mind….Nature has attended to…giving essential unity with boundless variety, so that the botanist has only to examine plants to learn the harmony of their relations."

— John Muir, *The Story of My Boyhood and Youth*

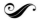

Wild pea flowers, Lopez Island

Overleaf: Driftwood, Lopez Island

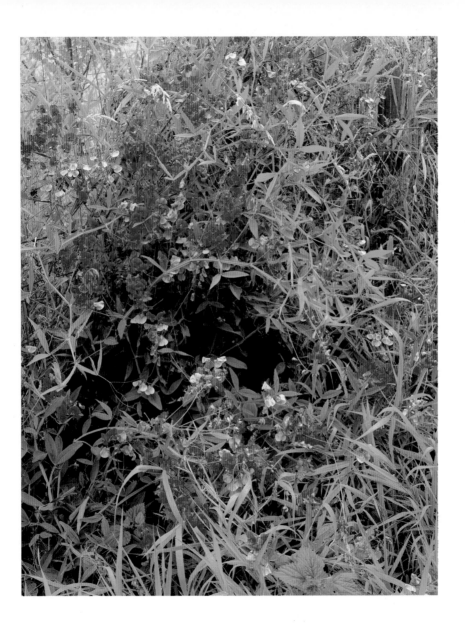

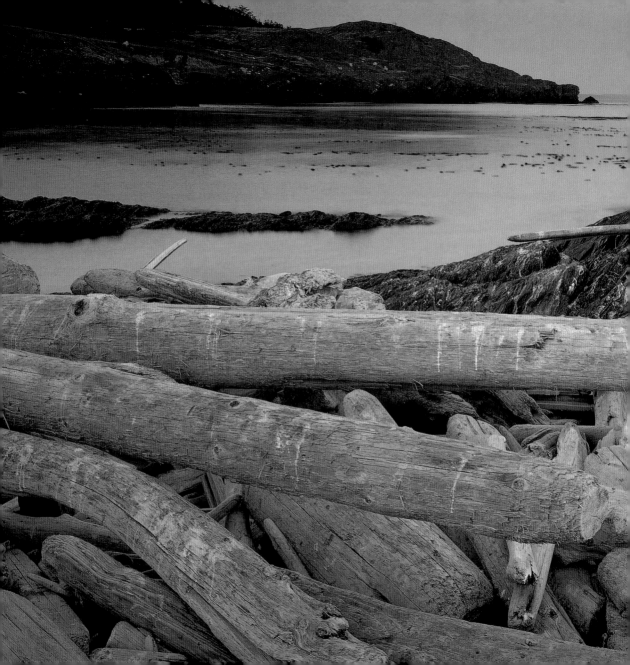

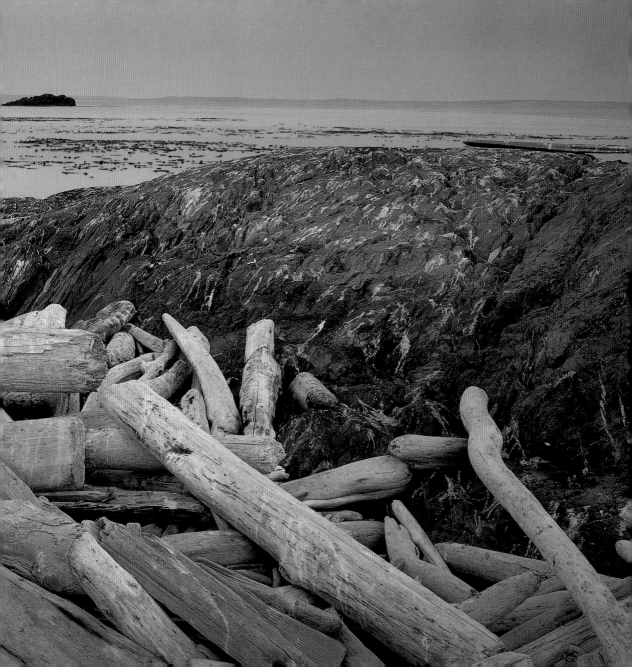

"Only spread a fern frond over a man's head and worldly cares are cast out, and freedom and beauty and peace come in…"

— John Muir, *My First Summer in the Sierra*

Ferns in golden hues, Shaw Island

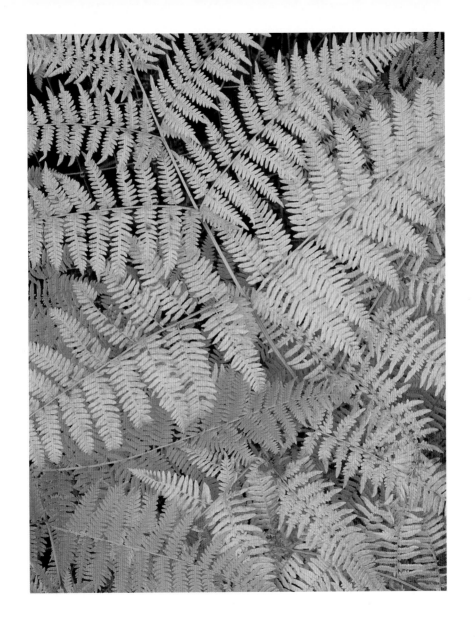

"The road was new to me, as roads always are, going back."

— Sarah Orne Jewett, *The Country of the Pointed Firs*

Maple leaves on country road, Shaw Island

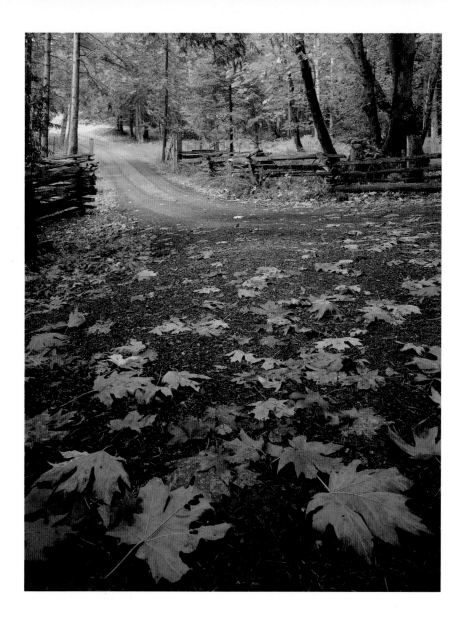

"Divinity is in its omniscience and omnipotence like a wheel, a circle, a whole, that can neither be understood, nor divided, nor begun nor ended."

— Hildegarde of Bingen, *Scivias*

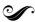

Millstone and wheel, San Juan Island Historical Museum

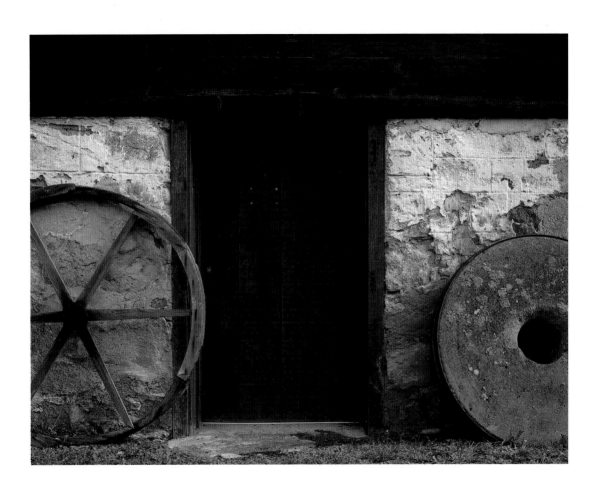

"The voice of the sea speaks to the soul. The touch of the sea is sensuous, enfolding the body in its soft, close embrace."

— Kate Chopin, *The Awakening*

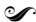

Strait of San Juan de Fuca, from Eagle Cove, San Juan Island

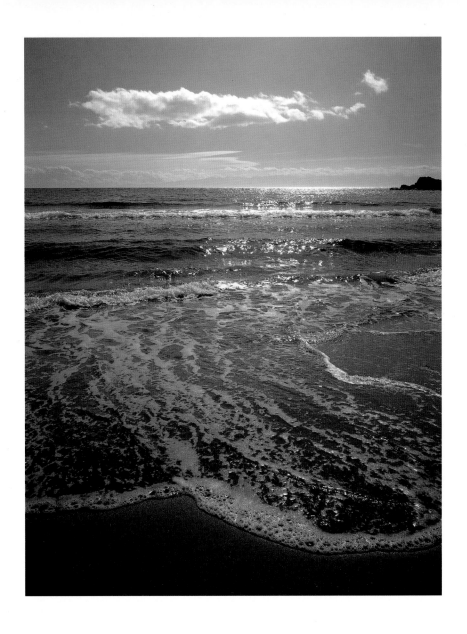

"A mollusk is a cheap edition [of man] with a suppression of the costlier illustrations, designed for dingy circulation, for shelving in an oyster-bank or among the seaweed."

— Ralph Waldo Emerson, *Power of Laws and Thought*

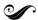

Pacific madrone berries and shell fragments, Orcas Island

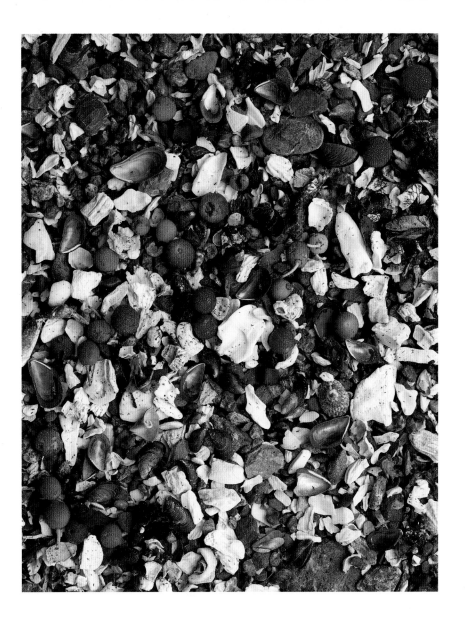

"Remember that the most beautiful things in the world are the most useless; peacocks and lilies for instance."

— John Ruskin, *The Stones of Venice*

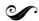

Yellow water lilies, Moran State Park, Orcas Island

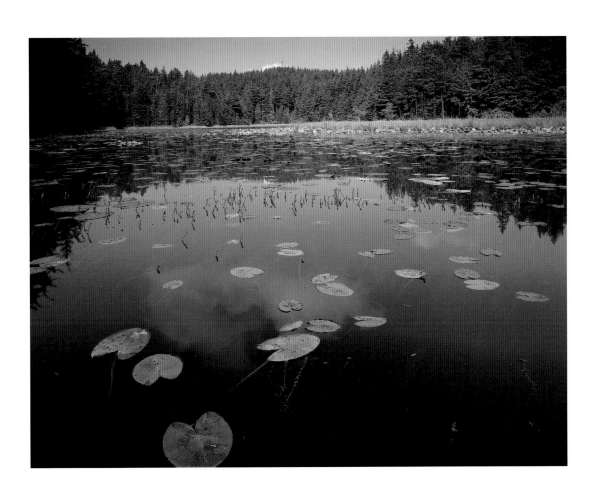

"To learn how [trees] live and behave in pure wildness, to see them in their varying aspects through the seasons and weather...you must love them and live with them, as free from schemes and cares and time as the trees themselves."

— John Muir, *Our National Parks*

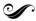

Moss-covered forest floor, Moran State Park, Orcas Island

Overleaf: Sunrise, Griffin Bay, San Juan Island

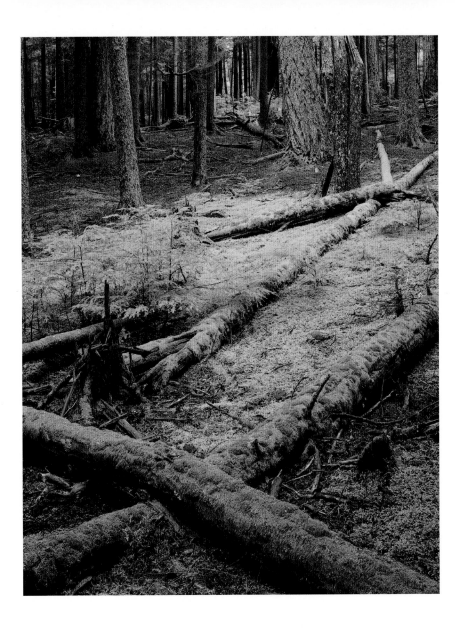

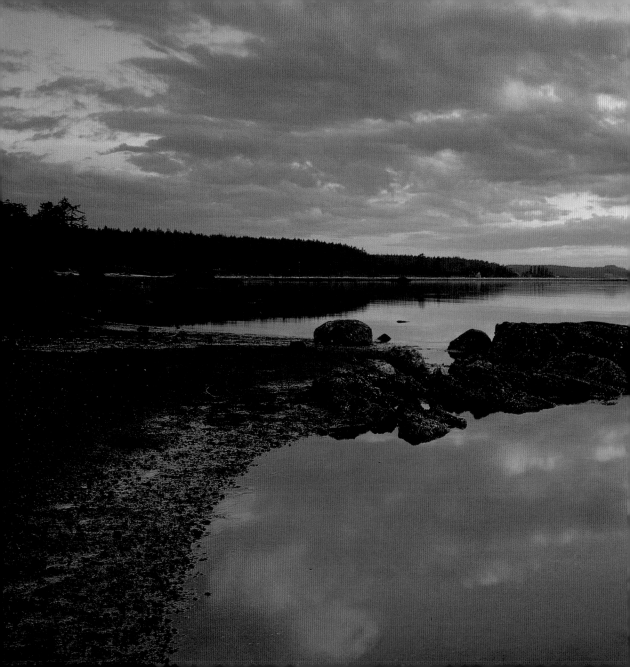

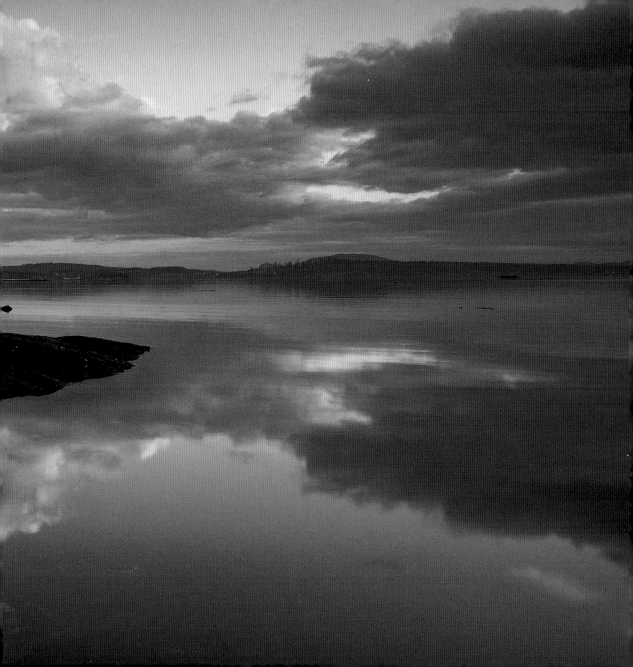

"I lingered round them, under that benign sky: watched
the moths fluttering among the heath and harebells;
listened to the soft wind breathing through the grass;
and wondered how anyone could ever imagine unquiet
slumbers for the sleepers in that quiet earth."

— Emily Brontë, *Wuthering Heights*

The San Juan Channel from Cattle Point, San Juan Island

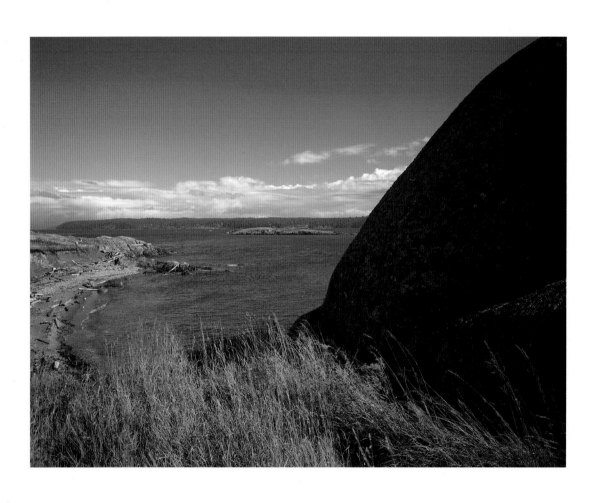

"The boughs of no two trees ever have the same arrangement. Nature always produces *individuals*; she never produces *classes*."

— Lydia Maria Child, *Letters from New York*

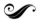

Madrone tree, San Juan Island

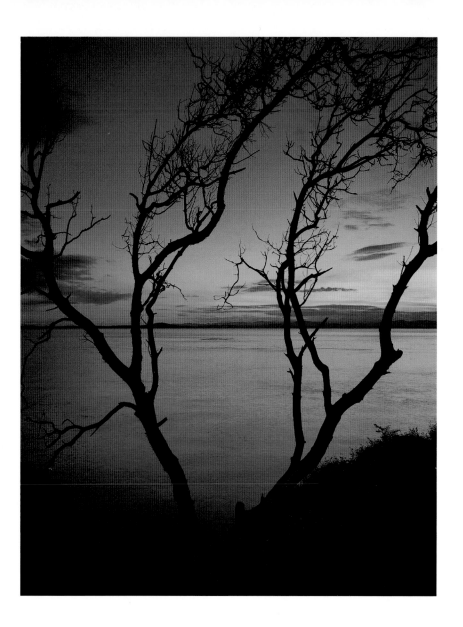

"To make a prairie it takes a clover and one bee,

One clover, and a bee,

And revery.

The revery alone will do,

If bees are few."

— Emily Dickinson, *Poems, Third Series*

Meadow of trefoil, San Juan Island

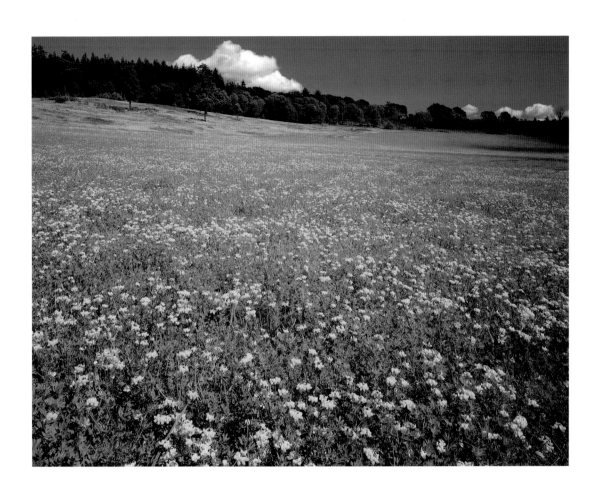

"In the life of each of us, I said to myself, there is a place remote and islanded, and given to endless regret or secret happiness."

— Sarah Orne Jewett, *The Country of the Pointed Firs*

Fishing nets, Friday Harbor, San Juan Island

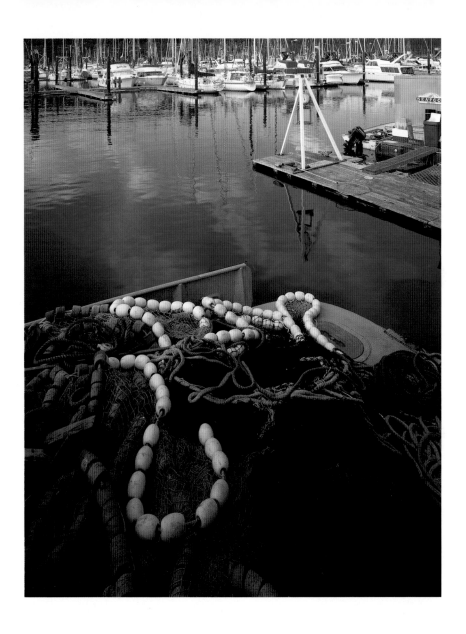

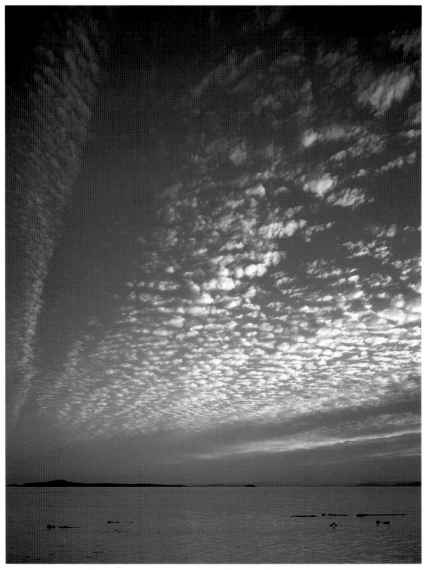

Sunset sky over Haro Strait, Sucia Island